Calculated Leap

Copyright 1999 - 2009 Theresa Devine
All rights reserved
ISBN 978-0-578-01251-3

This book is dedicated to all artists.

Together we can create a place where artists can make a living.

Acknowledgements

Many people have contributed to the development of this book. I would like to thank the following people:

My close friend and partner, Gregory Scott, for challenging me on every thought and for the brilliant design of this book. Steven Beach for his insightful editing. Scott Rexroad for giving me his perspective and knowledge about the American stock markets. Cheryl Bolton for sharing with me her excitement in participating the stock market and showing me how to invest.

All of the artists included who allowed me to utilize their work in order to illustrate the idea.

Preface

Artists are professionals. The making of art is a profession. The profession contributes to creativity, problem solving and critical thinking which all spurn innovation and adds value to the larger society. When I was newly graduated I expected to be able to make a living contributing creatively. I knew what I had learned had value. I was not so naive that I thought I would get a job as a studio artist but I expected the creative problem solving I had worked to cultivate in my person would be recognized as valuable and I would be able to utilize these skills to contribute in a way that would make a living. With the MFA, I had earned a black belt in creativity, was expert at conceptual acrobatics, aesthetic creation and conceptual deconstruction so why was I a security guard at the art museum? I had gone all the way, in a sense I had bought the tux and it seemed the party was over. I was all dressed up and there was no where to go. The identification of the issue in this book starts with that experience. The question that this book attempts to define and solve is "Why are artists starving?"

Table of Contents

3 Part I: The Stage is Set

From the Chicken Coop to the Meat Packing Plant: The Life of a Painting
What Good is Abstract Expressionist Painting in the 21st Century?
The Gift of Fire
Addendum: On Fire
The Wish of Modern Artists
Size Matters and the Hierarchy of Walls

13 Part II: Beside Myself: Troubling Observations

Down the Drain: On the Day Job
Stumbling Blocks and the Real Competition
India and Me
Religious Wars: Bucking the Status Quo
Membership: Club Creativity
Beyond Research and Development: On Creative Responsibility
Overstepping the Bounds: Mooching Intellectual Property

23 Part III: Step up to the Plate: Solution theory

When Impulsiveness Becomes A Calculated Leap
The Functionable Object: Answering the Question of Supply and Demand
On Ambition
The Creative Gold Rush
Addendum: The Rexroad Feedback
Choices: Guiding the Next Generation
Conclusion

37 Part IV: Accessing the Market: Examples of Implementation

Shane Harris
Andy Oleksiuk
Megan Abajian
Susan Smith Trees

Part I:
The Stage is Set

What

Art is an object, idea or experience that transcends
and becomes more than the sum of its parts.

is Art?

From the Chicken Coop to the Meat Packing Plant: The Life of a Painting

When I was a child we kept chickens in the summer time. There was only one rule: do not name the chickens. They were food - not pets. Every year I watched these chickens grow from cute fuzzy yellow chicks in the basement to smelly annoying dirty animals that I had to chase whenever they would get out of the coop to get them to my plate at Sunday dinner. The life of a painting is similar to this. It starts out small and quiet—letting a small peep out every once in a while. The artist nurtures it and treats it as if it is precious. Then as the dialogue with paint and canvas ensues there are moments of frustration – points at which the painting is lost and regained. At times you feel in control and other times the painting is controlling you. It invades your dreams and becomes obsessively present in your mind and soul. You think you must turn it to the wall to escape it for a while, but this does not work. The painting with all of its weaknesses and possibilities is demanding your attention. Your stomach starts to hurt as you feel you will never conquer it. Self doubt arises—perhaps you should have gone to law school creeps in your thoughts. Litanies of self-deprecating thoughts follow. Why did I think I could ever be an artist? Why did I ever think I could make a good painting? What kind of arrogance did I possess to think that any kind of message of mine would be important enough for others to witness or consider? The painting has become that annoying, dirty chicken chasing you and making you chase it to return it to the coop. And then it happens—
The Break Through.

The painting has a direction, a purpose for its existence. A resolution presents itself. The painting is ready for public consumption. And so, like gathering the chickens into cages and loading them onto the truck you prepare this thing you have created for its public life. Presentation and documentation issues are addressed. It is framed or not framed as needed, you shoot slides, you title it and you write an artist statement. And there it sits ready like a newly butchered chicken with its giblets in a little baggie neatly wrapped up in plastic—waiting for a consumer. If you are lucky enough, an audience notices it and it

becomes food, sustenance for the soul, feeding the dialogue between humans, the painting and the viewers giving life to each other. It leaves you then and takes on a life of its own and you return to the studio where another blank canvas waits quietly, peeping from the dark basement of your soul and asks you to feed it.

What Good is Abstract Expressionist Painting in the 21st Century?

Art is a humanity. Humanities are timeless. An abstract expressionist exploration is about depicting the world within. It is derivative of spiritual thoughts, concerns and beliefs which deal with things we cannot see, inner beauty or conversely inner conflict. This is and has always been a part of being human. Abstract Expressionism is always relevant.

The Gift of Fire

Let me tell you about the time I got drunk with Donald Judd.

My first year of graduate school three exchange students and I decided to drive out to Marfa, Texas to view the installation at the Chinati Foundation. A professor phoned ahead to arrange for us to stay for a few days so that we could experience the installation more fully. We set off in my 1980 Dodge Colt. After a grueling 15-hour drive we arrived and were escorted to the installation. I walked into a transformed helicopter hanger and a hush like the hush of an empty church greeted me. It was breathtaking. The fatigue from the trip melted away and the quiet meditation before me took over—transporting me to a more peaceful place within myself. After this initial introduction we settled into the barracks. A curatorial assistant extended an invitation to dinner and we accepted.

When we arrived at "dinner" we were surprised to see a table set for thirty people with Donald Judd sitting at the head. I remember the other students and I exchanged a look between us when we

realized what kind of a dinner we had been invited to attend. All the prominent people of Marfa were there. The mayor and ranchers from the area were all in attendance. It was definitely not our style. But the food was free so we stayed. After a meal of brisket and guacamole there was a concert.

The concert consisted of bagpipe music in a gymnasium. Imagine two hours of constant bagpipes echoing endlessly, the sound reverberating off the walls of the building. At first it was a bit confusing and annoying, but as the experience continued I felt engulfed and lifted to a Zen-like meditative place. When the music finished the group went outside and there was an unlit bonfire waiting.

The group encircled the wood and waited as an assistant tried to light the logs. His ignorance was apparent as he tried to light it—first in one place and then—another. At a moment of frustration he poured gasoline on the wood and still, he could not get it to light. Donald's embarrassment started to become apparent as the evening was supposed to be a carefully planned, seamless, spiritual meditation in commune with nature. I stepped forward at this point and asked the assistant to let me try. Knowing that if I held the flame in one place twice it would light. I did so and (due to the gasoline) the bonfire went up in a spectacular show of flames. The uncomfortable silence disappeared as the people relaxed. I sat down on the gravel, leaned back and enjoyed the leaping of the flames against the night sky and gazed at the stars.

As people began to leave Donald motioned my friends and I to join him. He took us to his kitchen and pulled out the leftover beer. We all sat down and a conversation began. It went something like this.

DJ: Do you think I am a traditional artist?

Emma: Yes, in light of all the things that are happening in contemporary art.

DJ: There are no contemporary artists—only people running around thinking that they are artists, wasting their time.

Chris: So you are the last artist?

DJ: Yes

Amy: Why is that?

DJ: Because my work does everything that artists have been trying to achieve. Now that I have reached the pinnacle, art is now dead.

Chris: So, art is minimalism; a pseudo religion in which a vector of nothingness is the pinnacle of enlightenment?

DJ: No - I am art and when I am dead, art will be dead.

The conversation continued in this vein for several hours. Emma, Amy and Chris all tried to argue that this artist or that artist was making important work and that was evidence that art was not dead. Donald remained unconvinced. I remained silent thinking that it was a pointless discussion. It was obvious that he would not be swayed from his position.

At the end of the night, as the first rays of dawn broke over the horizon, I finally had to ask. So why are you talking to us? Why would you waste your time with a bunch of delusional children? And he said to me, "Because you gave me the gift of fire." I looked him straight in the eyes and said, "So there is hope then." Very slowly, without blinking; he looked me in the eyes, and nodded.

Donald Judd died one year later.

Addendum: On Fire

I am neither as exclusionary nor as pessimistic as Mr. Judd. I believe all artists have the capacity to be perceptive and hold the match in the place where the kindling is already warm. Metaphorically speaking, we have the gift of fire within and the knowledge of where to hold the match to begin the reaction to bring renewal. A paradigm shift has begun and we are the catalysts. I invite all artists to join me in lighting the world on fire from within.

The Wish of Modern Artists

I admire most modern artists. Cezanne, Van Gogh and Renoir were amazing artists and have afforded me many happy moments and transcendent experiences. The experience they gave the world was one of solitude. They wished to be left alone in their studios and they wished for their audience to experience their work in solitude as well. They were extremely successful. So successful that it is commonly accepted that this is the way that art is and should be produced and experienced. All artists after them have mimicked this same delivery of art to the audience.

This wish of solitude is a nice wish, but it is not my wish. I wish to take what I am able to produce in seclusion and then work in collaboration to push the work to a new level. I wish to have masses of people experience the work in mass as well as in solitude. For me there is a singular experience, but there is also a communal experience. Humans crave both experiences and I am typical in sharing this craving.

Size Matters and the Hierarchy of Walls

When it comes to the matters of size, I have come to the conclusion that size matters. I was speaking to a small group of students recently and a question about showcasing came up. Is it worth the time and energy to show at a local coffee shop? I remember asking the same question when I was a student and the answer that was given to me was, "every opportunity to show is an opportunity to sell." In the same conversation it was brought up to me that once I had made a painting, I had a commodity and I could sell it and make more or dig a hole in the back yard and throw it in.

I think that this answer, while true, is too simple. I think that artists need to examine *why* they make work and what venue is really appropriate for their work. Is their intention to make luxury items for the elite? Is their intention to increase awareness about social issues? Do they wish to create moments of interflection? Do artists even

know why they do what they do? "I do it because I have to," is not specific enough. "I do it because I can't do anything else," is a cop out. An honest conversation with yourself about your motivations will reveal if a coffee shop or a movie screen is the appropriate place for the work. In deciding where to show, you are deciding the audience you wish to communicate with. A coffee shop is your neighbors. The gallery system is talking to your peers (preaching to the choir). Mass produced venues is communicating with everyone else.

In examining my own motivations for public display of personal expression I have decided that scale is very important to me because of its ability to communicate to a larger audience. I believe that art has the ability to effect social change and it is important to me that I get my message heard by as many people as possible.

So yes, size matters. Examine your motivations and which audience you want to communicate with and then place your work appropriately.

Part II:
Beside Myself

Troubling Observations

The trouble with troubling observations is that they are exactly that—troubling.

Down the Drain: On the Day Job

The other day I was talking to a friend of mine and we were discussing many of the ideas in this book. She had just graduated from art school and was concerned about paying back her student loans. I related to her how I had discovered that I could make a living as a programmer and obtain enough funds to pay all my bills, raise my family, pay for a studio and begin paying back my loans. And she looked at me and said, "But Theresa, are you happy?"

After the momentary knee jerk reaction to be condescending and tell the facts of life to my younger alter ego, I realized she had a point. The pursuit of happiness is certainly a fundamental human drive. What is happiness? What exactly am I pursuing? After much thought, I have come to conclude that it is the freedom of choice.

In a moment of serendipitous happenstance, I stumbled on Elein Gabre-Madhin (an economist from Ethiopia attempting to solve famine in her country with the establishment of a commodities exchange). She states, "[Happiness is] the freedom to choose where to live, what to do, what to buy, what to sell, from whom and to whom and how." She goes on to say that happiness is a fundamental right for all. It occurred to me that this applies to artists as well.

My answer to her question was, "No I am not happy." My freedom to choose how I make my living does not exist, nor does it exist for any other artist in my situation. It seems to be a luxury for a few artists who either have a wealthy (or at least financially supportive) spouse or have momentarily won the popularity contest that the current gallery system perpetuates. I work every day at a job I have learned to become good at because I am a provider. I have worked hard to achieve middle class standing and it is the plight of the middle class to pay bills, pay taxes and generally be the largest contributor to economic mechanisms. Not only do I provide for my family, I am a part of the backbone of the American economy.

When I come home every night I work on my real work—what I was born to do. There's always that little voice in the back of my head. I'm tired. I feel drained. I want to just be me. I want to be one person all the time; not one person during the day and another at night. I am not Batman. I am not super human either. I know that the quantity and/or quality of the work is hindered by this day job. I have to fight the fatigue and dig down deep in my being to find what got buried during the day. Yes it is very difficult. There are many artists who give up and all that creativity goes down the drain.

Happiness for me is to be just an artist. I would like to create endlessly and be able to achieve compensation for that contribution. It would be great if the world already had the mechanisms in place to support that choice. It does not. If we work toward saving artists from the creative drain of a day job we will create a world where happiness is achievable for everyone.

Stumbling Blocks and the Real Competition

The world is divided. On one hand there is the art community. We generally referred to this community as, "the gallery system." In order for the system to survive it has created value by fostering a mystic of the artist as genius or recluse or idiot savant or freak. Additionally the galleries have sometimes hindered creative growth of individual artists by a need to have a visually and conceptually consistent inventory. Once an artist reaches "maturity" only slight variations will be tolerated. Only a few artists have been able to escape this restriction. Even with all its efforts to survive and grow the gallery system cannot support every artist and, what's more, it is not their responsibility to support every single one of us.

Since there is so little room within the system for newcomers', competition is created among artists that is unhealthy and counterproductive to the creative endeavor. In order to survive artists turn to the government and institutions for a handout in the form of grants. This contributes to the loss of perceptual value of the role of the artist in

the larger society. So the world perceives the artist as they would a career welfare recipient. As a person who is constantly asking for a donation and unwilling to work for themselves. As a result, funding to art museums, alternative spaces and academic departments has been cut. The rise of a visually illiterate conservative right has exacerbated this trend. These forces are a stumbling block that have stunted the pursuit of artists. This pursuit is to reveal the depth and breadth of our potential and to extend humanity beyond its limitations.

On the other hand there is the Hollywood image making machine. Every day a new set of completely meaningless, visually spectacular, conceptually barren sensory information is released to the visually illiterate audience. This machine is masterful at seducing the masses and has won in the battle for the attention of the audience. Hollywood is the real competition in securing an audience and a market share. The competition between artists is silly because fine art does not stand a chance. We are boring in comparison.

Life Flight Helicopters

The problem with handing money to an artist and walking away is it the same as giving money to an adolescent. They will buy some cool things, they will benefit themselves or they will satisfy some immediate gratification. The money given to an artist is not an investment at the moment. Artists see any money as a gift and they do not have the responsibility to make the money they receive give back. Since artists currently feel they are exempt from accountability, the current location of an artist is in the liability column in the ubiquitous spreadsheet. In the case where an artist has actually made something of value, they often devalue the work and the investment is lost. The metaphorical life flight helicopter in the form of a grant is not helping an artist stand on their own two feet. It contributes to a perpetual spinning effect instead.

We need to encourage artists to think as entrepreneurs do and make sure that their contribution gives back to society. This contribution needs to be economic as well as creative. I view artists as I would

doctors. We give a priceless value to the world by giving of ourselves for the common good but, like doctors, we need to be compensated for our contribution. Artists need to revise their belief that what they do is not valuable and cannot or should not bring them financial gain. If artists begin to see their place as an economic asset for the larger common good then grants, loans, investments all begin to make sense. Money will flow freely between the investors and artists. Artists then become the life saving helicopter for society by contributing creatively and economically.

India and Me

I never have to go to India because India came to me. Currently, I make my living with left brain activities. (Yes I know the whole left/right brain theory has been disproven but the metaphor is still useful.) I am a programmer. The work I do is easily outsourced and currently that is the trend. I compete with people from India for the jobs that are still in America. When I first started in this profession ten years ago, the team I would work with was made up of me and five guys. Now the team is me and five guys from India. I would note here that depending on where I am working there might be representatives from China, Russia and Pakistan as well, but Americans (all races and genders) are underrepresented in the profession and India makes up the majority of the teams I work with. There is fear among American programmers that making a living will become impossible because all the jobs will be outsourced just like the steel workers of the last generation. Those with their eyes on the eight ball, so to speak, are becoming business analysts (these people write down the project requirements to give to India) or project managers.

As this trend continues, the option to "fall back" into left brain day jobs will disappear for artists. As this continues, the importance and need for right brain jobs will increase. These jobs have not been defined very well yet. Daniel Pink is talking about this possibility when he says, "the MFA is the new MBA" There was even one financial services company in Manhattan advertising for a new

creative R&D think tank on the College Art Association website. They were only paying 50,000 a year though. So this company understands the value of artists but is unwilling to compensate for it. Still the listing makes me hopeful. I suppose this is the job listing I was looking for 14 years ago.

My plan is to fall back on my art. Programming saved me momentarily from poverty, but my art will set me free. I might even outsource to India in addition to my staff on American soil to make my art. Then the circle will be complete.

Religious Wars: Bucking the Status Quo

Currently, a notion is being perpetuated that anyone who makes known their desire to earn a living as an artist is compromising their artistic integrity. This narrowly defined identity creates the generally accepted belief that earning a living and true artistic exploration are mutually exclusive goals. This silences artists who think otherwise and the status quo of starvation is allowed to continue.

To refute this I will quote Dr. Amartya Sen, "To be generically against markets would almost be as odd as being against conversations between people…The freedom to exchange words, or goods, or gifts does not need defensive justification in terms of their favorable but distant efforts; they are part if the way human beings in society live and interact with each other…the denial of access to product markets is often among the deprivations from which many small cultivator and struggling producers suffer under traditional arrangements and restrictions. The freedom to participate in economic interchange has a basic role in social living." This passage, from Development as Freedom, describes the experience that most individual artists have today. Individual artists are suffering (i.e. starving) because of the denial of a basic human right to access the market.

The gallery system is a traditional market of old and has the same restrictions as the pre-commodities market. The producers (artists) who are lucky enough to gain entrée to this market cannot predict the

sale of their goods and they are privy to the terms and conditions set forth by the galleries. Traditionally, a gallery typically takes 50% without any negotiation or contract. Any artist who suggests that the percentage is unfair or would like to formalize the business relationship with a contract is deemed "uppity" and the agreement for representation is terminated. Artists stay silent because they have no alternative. Artists typically turn over tens of thousands of their own inventory without a written contract. The gallery business model is like any retail store, but, inventory is not purchased, it is taken on spec or as consignment. The other retail establishments that do this are used furniture and clothing stores. What does this alignment say about the value of art? Additionally, galleries are notorious, as a group, for unethical practices and for failing to pay artists for sold work. The power is in the hands of the few distributors who would not have a job without the producers of the commodity.

Artists should have the confidence to enter the market unabashedly and demand negotiation of commission percentages solidified through contractual agreements when dealing with the current gallery system, create new ways of distributing their goods and services and to pave the way for other artists. Buck the status quo and let the rise of the creative class begin.

Membership: Club Creativity

The reason why tenure track positions are so coveted, in addition to the economic stability they represent, is that these positions firmly establish the membership of the artist in the creativity club. It is perceived that creativity only happens within the confines of these special places and that the people capable of creative endeavors are these special people in these special places. This attitude permeates the profession. When people meet me, they ask me where I teach. Before I started teaching one class I would say "nowhere" and often be dismissed. There was a marked change in how I am treated because I can now say, "I teach at [name of school here]." Who I am as an artist has not changed, but the perception of how good I am at being an artist

is measured by whether or not I am teaching. I am a respected member of the creativity club because I teach one class. That is ridiculous.

This predilection has also effected the education of our children. I have heard repeatedly from children and adults that they have gotten the message from their schooling that they were incapable of creativity and only those "with talent" were creative. That's crazy. People are naturally creative and everyone is capable of creation. It is a part of being human. Everyone is a member of club creativity and what is more, because of the challenges we face in becoming a global village this creativity is essential to the growth of the global community. Artists are the leaders. We need to cultivate the creativity club and make sure everyone knows that they are a valuable member in the club. It is not just for special people in special places.

Beyond Research and Development: On Creative Responsibility

What kind of crime would it be if the scientist who discovered the cure for cancer never got the cure to a pharmaceutical company and never distributed the medicine to the public? What if she/he threw the solution in a drawer and forgot about it? This is what artists do everyday. They research and develop, explore and create and then put everything in storage or in the trash. They devalue their own work.

The cynical 80's taught everyone that being an artist was useless and art does not affect any kind of social change. Artists bought this, hook, line and sinker. It is fashionable to be cynical. When I meet someone under the age of 30 with this attitude, I wonder, "What have you got to be cynical about; you have barely begun to live." This belief has been adopted from a misunderstanding or influence of Ironic Abstraction, Post Modern or Chaos Theory. It must be a meme of some kind. I suppose one or all of those are to blame for this common and wide spread notion. What is important here is to point out that it exists and to ask artists to question themselves, "Do they carry this mind-set?"

I think artists are playing an extremely important role in the pioneering of the creation of humanity's future. This contribution is as important as the cure for cancer. Not only do we have a right to participate in the market, we have a responsibility to distribute our creation to the public. And just like the scientist who discovers the cure for cancer, we deserve compensation for our discovery. Also, just like the cure for cancer would benefit a wide range of people economically, artistic creation would also have this wide reaching beneficial economical effect. So get out there, embrace your inner capitalist and get your voice heard. It is your responsibility.

Addendum: The Crash and the Renewal

This essay was written about a year before the economic crash that happened in the fall of 2009. I would like to suggest that the economic contribution discussed in this essay is the key to economic recovery. The innovation that artists' are capable of spurring has the power to renew the economy.

Overstepping the Bounds: Mooching Intellectual Property

I have noticed a conceptual mooching practice among insecure art risers who make "art." These people are not artists but they think they are. They might even have been an artist at one point, but something happened to turn them into a backstabbing, conceptual thief and gold digger, instead of the creative force they might have been. Ironically, there is no gold in the art community as it is today. The people caught in this system justify their behavior by rationalizing that they need the ideas more than the artist they stole the idea from. The targets of their mooch are often younger artists who have not obtained a tenure track position or artists who have no intention of pursuing a tenure track position. After all, they have to make tenure. What is more, I have heard this rationalization from the "victims" as well as the offenders. I am not looking to lay blame but I am looking for a reason why this happens. In part, it is not their fault, in some

cases it is perpetuated by some professors responding to politics within an art school and the pressures to obtain tenure.

The ambition of art school creates tremendous pressure to make work, get shown, obtain grants and become published. This pressure supersedes any commitment by faculty to pursue a true path of research or to guide their student's true path to discovering new venues of research. The faculty focus on the "art career" and ignore the exploration that is involved in the creation of art. The school builds its reputation by pursuing the "star" artist as a lure for obtaining new students. This also assumes that a well marketed artist will make a good teacher. Sometimes a person who would have been an artist is transformed into a caricature of an "artist" making "art." It is a very sad thing to see. These people become extremely insecure and lose any focus on any honest life derivative as an impetus for the work.

Why is it important for me to point this out? An artist's bread and butter is their intellectual property. The net worth of an artist (yes financial net worth) is determined by the quality of the intellectual property and the marketing of that intellectual property. When an "artist" pursuing an "art career" makes "art" by mooching conceptually, it hurts the artist's (the originator of the idea) ability to make a living. This is no ethical dilemma in my mind. It is theft. It hurts. The object of your mooch is a fellow artist who has responsibilities to contribute to their family's income or support a family, pay taxes, pay debt, invest in stock and plan for retirement. You are kicking a fellow artist in the groin when you mooch. Don't do it.

I would like to make a point here that mooching is different than influence. Influence is what happens when you understand or misunderstand someone else's work and it helps you understand your own work more fully. We don't live in a vacuum and no one wants to stick their head in a hole in the back yard or go live in a cave on top of a mountain, so we will all be influenced. This is why ideas are not copyrightable. But if you cannot trace the work you are doing back to your own childhood or your own life story without any kind of artificial mind-bending acrobatic convincing, you are mooching. Your work should organically grow from your life experience. Period.

Part III:
Step up to the Plate

Solution theory

When Impulsiveness Becomes A Calculated Leap

When I was 23 my favorite thing to say was, "There is genius in boldness." This was how I viewed and justified my life and my art. At the time, my art was very much like my life—chaotic, unpredictable and naïve. I did not have time for sketches and planning and thought that most artists who did this were not in touch with the power of intuition. I did not even bother with a palette and squirted my paint directly from tube to canvas. Letting the paint take me where it would, like a feather adrift in the breeze or like debris flying loose in a hurricane depending on the mood of the day. I did not care for aesthetic theory or art history. What did that have to do with me? I only looked at other painters for technical guidance and I never read those books with the recipes of the masters. My peer group and professors alike often described me as impatient.

However, there was a nagging feeling that the impulse to make art was a result of the need to expose or say something. As I progressed into life after school the speed of my paintbrush slowed and the nagging became unbearable. I began to think about why these objects must exist. I thought there must be more than an existentialist extension of the tradition of abstraction. The words of the Catholic and Buddhist mystics that I had read in school blurred and faded. There must be something unique about the contribution I and every other artist had to make. If there wasn't something more to contribute then what was the point?

The making of objects ground to a halt.

I began to study the world; listening to it instead of my own incessant chatter. I collected news stories and advertisements, scavenging life bits trying to fit together the pieces of the puzzle. There must be more… there must be more… replayed like a mantra in my head. I was fully immersed in what I now call my incubation period. I had passed a point of no return. The realization that I must leave that which I loved the most in order to create something else was excruciating and invigorating all at once. I was reborn and fully vulnerable.

Patterns began to emerge. It was like a kaleidoscope with a ubiquitous hand turning the view port. The patterns would shift and suddenly the pieces would make a different perspective—a new image. Stocks rising and falling, economic shifts creating and destroying jobs, a well placed vote to prevent or start a war, the relation of taxes to providing to those in need, science and technology and its membership to creativity and the Hollywood image machine. Then I realized—it was not a ubiquitous hand turning the view port– the hand turning it could be mine if I possessed the confidence and courage to reach for it and make a turn of my own. It was not that my hand was more important or less important than anyone else's—it was that it was MY hand and my hand is as valid as anyone else's. I gave myself permission to contribute—permission to shift the view port and let others consider the perspective.

All of this coincided and collided with my participation in the corporate world. The corporate world from the perspective of the artist is a fully planned, calculating machine, which is often considered an evil force manipulating the masses for the betterment of a few executives. While I will not deny that this happens, I have also found (through experience as an employee) that the corporate world is also a place that is perhaps more creative than that of the art community. For example: A multi-billion dollar media corporation being started with a poker game of used car salesmen and a radio station owner (i.e. Clear Channel Communications – think what would have happened if Howard Stern had been present at that poker game and had won that hand). In contrast the art community appears to be a stagnant place with all artists lock stepping Nazi style to the demands of the establishment. For people who purport to be creative, I don't see much creativity in the choice of how most artists choose to live their lives.

As I became fully cognizant of the power of the corporation and the idea that this world could be used as if it were a canvas with investment and return a set of paints and brushes, I also became aware of the possibility of what could be, should artists allow themselves to participate. What kind of a world would it be—if artists formed

corporations? The desire to fully participate in the world allowed me to begin to plan and calculate how and when I would make the next leap. It would not be a blind leap of faith but a leap where I would be sure of where my foot would land on the other side of the canyon. Of course like anyone who decides to leap across a canyon, all the planning and calculating of rate of speed and angle of trajectory could be made useless by one gust of unexpected wind.

In the post-Enron corporate world anyone who participates must also realize that it is not the rock of Gibraltar but more of a ship at sea—privy to the weather and the currents—with the combined possibilities to go anywhere and find undiscovered territory or find a grave at the bottom of the murky depths.

And so—at 38 years old—I amend my earlier thought to say, "There is genius in the boldness of planning and the calculated use of intuition."

The era of the Corporate Fine Art Entity has begun—where leaps of faith are calculated and artistic contributions planned and delivered to the masses.

The Functionable Object: Answering the Question of Supply and Demand

Whenever the question of the inability to sell works of art comes up, there is always a voice who will interject the issue of supply and demand. When art objects are sold as a luxury item in galleries the artist is entering into a market where the supply is much larger than the demand. This is why I am making the suggestion that artists make "functionable" objects instead. Here is the breakdown of the types of objects we can create as artists.

Traditionally art objects have been either functional or not. There are countless seminars fashioned around this issue at every art school. In a nutshell, functional art is usually a recognizable sort of object with a known mode of usage. It is widely utilized, enjoyed and understood.

On the other hand there is the non-functional art object. It is found on the walls and pedestals of galleries, museums and collector's homes. It has no function other than to be itself. Its only objective is to carry a message and provide a transcendent experience for the viewer. The goal of the art object is to expand the perceptual boundaries of humans. It defies the notion that an object must have a utilitarian application to justify its existence.

There is a third option in the function versus non-functional discourse. The "functionable" art object. The functionable object has characteristics in common with both functional and nonfunctional art work. It is transcendent like non-functional gallery objects, but it has a purposeful positioning and demeanor that allows it to function in the societal arena. It delivers to the viewer a transcendent experience in an easily recognizable, easily understood package. Because the viewer is able to enter the artwork the meaningful exchange between artist and audience is more readily facilitated and because it is a package that is wanted and a part of the mainstream market, it affords its creator the opportunity to be compensated for their creative contribution.

On Ambition

No one is more ambitious than I am. But why am I ambitious and who am I ambitious for? What good does ambition do?

Currently, the question, "Why do we hurt each other?" provides navigation to the development of my artwork. This started as a result of a personal violent experience and has been strengthened by my increasing awareness of other hurtful experiences in the local, national and global communities. For example, 9-11, the war with IRAQ and the relationship those two events have with each other. I believe that these things occur because the persons involved believe they have a right to act as they did. If everyone feels this way and does not acknowledge the validity of the other point of view then the world will never be a peaceful place. My work will help

individuals discover how to create a world where tolerance, cultural awareness and diversity are valued.

The significance of my work is to increase people's self awareness of the role that malleable belief systems play in forming our world. I hope to effect change in how people interact with each other not only intimately but also in a local and global community. I hope this work will change how people perceive themselves and their importance in the world. I hope that they will vote more thoughtfully and deconstruct the media more critically. I hope they will be more cognizant of their effect on others and be more respectful of diverse lifestyles and belief systems.

It is my responsibility to manifest this work in the world. The ambition is not for me, it is for the message to be heard. Additionally, I wish to pave the way for other artists. Other artists also have important contributions to make and any gains in understanding or creating opportunities for venues will be passed on. I am not only ambitious for my own message to be heard, I am ambitious for the messages of every artist to be heard. I hope to benefit everyone with my ambition. In a world where most of the artists believe that they have no significance and at best their work will only affect a few people and that their own personal ambition is a negative trait, I am lending my ambition to them. Hopefully this will create a world where artists will believe in themselves again and believe that the work they do truly does change the world and this collective work does change the course of history.

In this book I have identified problems with distribution channels for art and proposed solutions. These ideas are not the only possibilities available to these problems, but they are the ones I invented. Hopefully, this will start a dialogue among artists about other solutions and other proposals will be inserted into the discourse.

The Creative Gold Rush

"I have so many ideas. I wish I could find a benefactor or get a million dollar grant so that I could do them all." How many times have you heard this from your artist friends? This statement (or one similar to it) is uttered too many times around the world every day. American artists like to throw in a comparison with Europe and its exemplary support of the arts and lament about how the USA does not understand or support its arts. Soon after, a discussion ensues of Jesse Helms and the downfall of the NEA and the subsequent demise of art education in the public schools follows. This contributes to visual illiteracy which exacerbates the situation. We all know that the funding for alternative spaces is dwindling, the competition for professorships, gallery representation and grants is fierce and as a result artists are guilty of the backstabbing, money grubbing, brown nosing behavior that we all criticize the rest of the world for exhibiting.

My fellow artists, what are we going to do about it?

I believe that the first thing we have to do is address the victim mentality that is underlying the original lament. "Get a benefactor or get a grant," means we just want things handed to us. This sentiment reflects that artists do not feel they are privy to the test of proving worth that the rest of the world has to attest to, day after day. The thing is, we are privy to it and the downfall of the NEA is proof. I suggest that we dump this old attitude and start to think and say to ourselves and to the world: "My art has merit and this is how it has value conceptually and financially." All the way through school my professors said over and over, "Art is a business." Ok I will buy that (no pun intended), if art is a business then where is the stock? I want to invest.

The second mind-set that presents a roadblock is the general belief among artists that if you are financially successful as an artist you must have sacrificed your artistic integrity to get there. Let's give this belief some consideration and assume that it is credible. You can find proof everywhere. Thomas Kinkade and Anne Geddes have absolutely no artistic integrity. Their work is laughable, but yet it has broad

appeal. They bring home the bacon and have employees to boot. This is proof that the work has to be vacuous conceptually to be mass produced and sold. I would say, "We are smarter than them." We can make smart work that has broad appeal. It is just harder than making sentimental fluff with an inane concept. We can do it.

The other elephant in the room is the voice of academia declaring from on high that they have preserved their artistic integrity by retreating into the ivory tower. These are artists who have had nominal success in the gallery system, but are tenure track. I would say that they are suspect because they are the ones who have mastered that particular marketing venue. For an artist to win that finicky competition, the work has to be able to function academically. No one who is too controversial is found in most universities. You can't be too far "out there" and you need the support of other academic institutions on your vitae. And by all means—keep your mouth shut so that you don't offend anyone unless being offensive is your persona. Some of those on the inside perpetuate/preach their opinion that artists, other than those in the club, have no right to make a living in the profession and if they do, they must be sacrificing artistic integrity. Those that don't, keep quiet for political reasons. I would include the entire gallery, grant, residency and educational system to be a part of this scene. I think it holds back artistic exploration and places constraints on an artist's development in a different way. Are there people who have been able to fight these constraints? Yes, but they are few and far between. The situation is the same as the venue of mass production. Retreating into academic circles is not an answer.

The point is, each possible distribution venue has the same challenge. It is up to the individual artist to hang on to their integrity as they move the work from inception, to the studio, to distribution no matter what venue they choose. It is up to the artist create desire for their work. This lesson is taught to us by Thomas Kinkade and Apple Computers.

And so, back to my earlier desire, I wish to invest in art.

It would be great if people were able to:

1. Buy stock in companies that have the intention of making art.

2. Invest in an Art Index.
(Nanotechnology has one [PXN]—why not us? We could call it the AI 500 – pun intended)

3. Speculate in Art Futures.

4. Participate in options trading in art stocks.

As these thoughts became clear to me, I decided I would see what I could find to invest in. I tried to compile an Art Index. I found Sotheby's [BID] right away and did my research to discover that if I invested $100 initially and then $100 a month from Aug 2003 to the present (Feb. 2008), I would have invested $5200 and the stock would have a market value of $10,800 (approx)—I would have doubled my money minus the brokerage fees.

Sotheby's is a good investment and just about the only stock I could find that qualified as an art stock. But it does not fit my criteria. They do not intend to make art, nor do they encourage contemporary art production. They deal strictly in the secondary market which rarely benefits the individual artist.

Then I thought, maybe the Art Index could be made up of companies who inadvertently make art. The first one that comes to mind is the makers of the iPod [AAPL]. If Apple was an artist, her/his concept would be to create seduction and desire and he/she would be doing an awesome job at it. From an investment point of view $5200 invested in the same way I did in the paragraph above would have a market value of approximately $23,000. A wonderful return, a wonderful company, but they are missing my number one criteria and that is to intend to make art. The bottom line is, they intend to make electronics and they use desire created by high quality product design to sell them.

I then considered Sony Pictures because they made the film "Adaptation." But Sony doesn't care about art and they have no intention of making it. If they happen to fund a movie that is art, as in the case of the above mentioned movie, it is by accident. I want to invest in Charlie Kaufman. Now he is an artist I could really get behind. If only he had stock.

I went through similar thoughts and research for Edios Interactive (Warren Spector's Deus Ex and Thief series) and Big Beach Films (Little Miss Sunshine). Edios has the same issues as Sony and Big Beach Films is private.

I delved into artists who have private companies next. There I found Kinkade, Geddes, Hirst and Koons. Kinkade and Geddes are just bad artists and they're not publicly traded, so I wouldn't be able to invest, even if I got over my gag reaction. Hirst and Koons are interesting artists to look at as investment possibilities. They took the Warhol idea of the Factory and ran with it. They are generally considered to be good artists and both have formed corporations. Science Ltd is Damien Hirst's company, and Jeff Koons Productions, Inc, is the corporate entity keeping Koons from being personally liable in court. (Sidebar: Jeff Koons was a commodities broker for 6 years after graduate school.) For a very short time in 1998 you could buy stock in Damien Hirst's Pharmacy (Hartford Group). His attempt at a pharmaceutical-themed restaurant did not fly very well. Other restaurants started by the company were poorly managed and also did not make any money. I should say that the Hartford Group had other people involved in it and was not an exclusive Damien Hirst venture. Maybe if it had been it would have made money. In these two artists, I see a glimmer of what the future could hold. If they had stock I would put my money on them.

At this point the reality that what I was looking for did not exist dawned on me. The world I was/am looking for has not been created. There is no Art Industry. There is no stock, no indices, no mutual funds, no futures or options trading. There are some art "hedge" funds out there but my invitation to invest and/or participate in it must

have gotten lost in the mail. They are inaccessible. (By the way, futures trading would be perfect for funding art ventures.) Investments in art would provide a new source of revenue for artists to create their work unobstructed. They could use the investment money to profit personally and commercially and begin to have an impact beyond the studio and gallery. Artists who have no intention to be educators would have the choice of staying away from the classroom. The credibility of the profession of artist would be restored and we would have the collective ability to fund our own R&D (grants, scholarships, etc.) and other altruistic endeavors.

We have work to do, we need to stop belly aching about the over saturation of the gallery and academic systems and start hammering out the industry that is ours. It is wide open and there is plenty of room. It is a new frontier. This frontier is very exciting because it is the place where artists can stop competing with each other (at least at first) and come together on the common goals of creating and exploring to reveal the breadth and depth of humanity's potential and to extend the boundaries of civilization. It is time for the gold rush of creativity.

Addendum: The Rexroad Feedback

I gave this book to my stock broker friend who sits in the cube behind me and he had some very interesting feedback. Here it is:

1. My examples are taken from a time period during a bull market. He could choose another time period when the stock market wasn't doing so well and could illustrate the converse argument.

2. Competition is what the market is all about. However, and it is the however that is important here, it [the market] spurs innovation and makes everyone's piece of the pie bigger. This is what I want for artists.

Choices: Guiding the Next Generation

It is obvious that the way we teach our students, young artists, is outdated and needs reform.

We need two new degrees and we need to revamp the old one. The new ones are called the Master of Fine Business Arts (MFBA) and the Master of Fine Educational Arts (MFEA). The one that needs to be revamped is the Master of Fine Arts (MFA).

When a studio art major enters graduate school they should be asked to decide which of these tracks they would like to pursue. Currently, the assumption is that they will teach and show in the gallery system. Everyone earns what I propose to be the MFEA right now. This is problematic because we have people teaching who have no business teaching just because they are pursuing economic stability. To avoid this pitfall, we need more vocational choices for the next generation. Here is how it could work:

First Semester

Seminar: Explore your motivation to make art. Create and deconstruct your artist statement. Examine the history of your work. Decide what you hope to accomplish with your work.

Second Semester

Seminar: Determine placement in the market for your art. This is related to motivation and what you hope to accomplish. Form follows function.

Third Semester

Choose a vocational path: Business, Education or Studio that is a derivative of your conclusion of your seminar exploration from the first year. Depending on the choice, the students are given guidance in education, business or navigating the current gallery system.

Note: It is assumed that everyone will be making art of some kind.

If Education (MFEA) is chosen then the students enter into a program where they will teach, write a teaching philosophy and develop curriculum. Connections with educators and academic institutions are cultivated. This is approximately the current MFA.

If they choose Business (MFBA) then they will learn about planning, finance, distribution and marketing. They will be given opportunities for internships and develop a business plan. There will be seminars on business ethics and what is unique about an artist run corporation apart from "regular" corporations. Connections with investors and entrepreneurs will be cultivated for the students.

The third choice is for the student who determines that they need no vocational application of their work in their lives. They will begin digging a hole in their backyard or they will be exposed and connected with the current gallery system and explore other creative ways to gain exposure for their work. This would be studio art in its purest form and become the new and improved MFA.

Interdisciplinary exploration will be encouraged as well. For example, if an MFEA major would like to take an MFA seminar in approaching galleries or an MFA major would like to take an MFBA seminar in writing a business plan, this would be encouraged and supported.

We have a lot of work to do. If you're a professor at an art school, copy and paste this and take it to your department chairs.

Conclusion

Why are artists starving? The conclusion is simple. Artists are starving because they have no access to the market. They are in the same predicament as the Midwest farmers of 1848. The farmers of yesteryear used to send their grain up the Illinois River to be sold at market. If no buyer could be found they would dump the grain in Lake Michigan rather than pay for shipment back to the farm. I did this myself when I moved from Corpus Christi to Houston in 1991. I did not have the money to move all of my paintings, so what I couldn't

give away, went into the dumpster. I am sure that this experience is typical. Every artist has probably done this at one point or another. It is not that the goods are not being produced; it is that the system which connects buyers and sellers for artists is underdeveloped. There are well developed functioning stock and commodity markets in the US. The NYSE and NASDAQ do their jobs very well. Artists have not claimed their place in those markets. We have not carved out our niche, put a stake in the ground and defined an industry that is referred to as, "The Art Industry." Dr. Amartya Sen won the Nobel Prize in 1998 for pointing out that famine is not about the availability of food supply but about the ability to entitle yourself to that food through the market. If you are starving then it is because you are unable to access the market.

After all this thinking it occurred to me, it is not that the party I had prepared myself for was over; it was that it has not yet begun. So to quote one young singer, "Let's get this party started."

I am calling on all artists to make functionable objects or experiences, to push beyond research and development, mainstream their work and create publicly traded companies that will become the Art Industry. I am calling on artists to step up, define and create their place in the market.

Part IV:
Accessing the Market

Examples of Implementation

Shane Harris

Impetus Shane's work addresses issues of fertility. The work resembles seed pods or sea plants and/or creatures and has an elemental message about the structure and beauty of nature. The pieces he has produced reveals an interest in discovery and play because aesthetic surprises occur as the viewer experiences and handles the work.

R&D Small mixed media ceramic sculpture that is phallic in nature and creates moments of delight when experiencing discovery.

Mainstream application Playground equipment. Reproduce the work larger and this will also give the artist a chance to explore the elements of play and discovery. The change in scale would also allow for many more layers of discovery as the small scale sculptures while jewels of hidden treasure do not allow for more than one or two discoveries. This application of the work would introduce the beauty of nature to children and help them become adults that cherish nature, discovery and play.

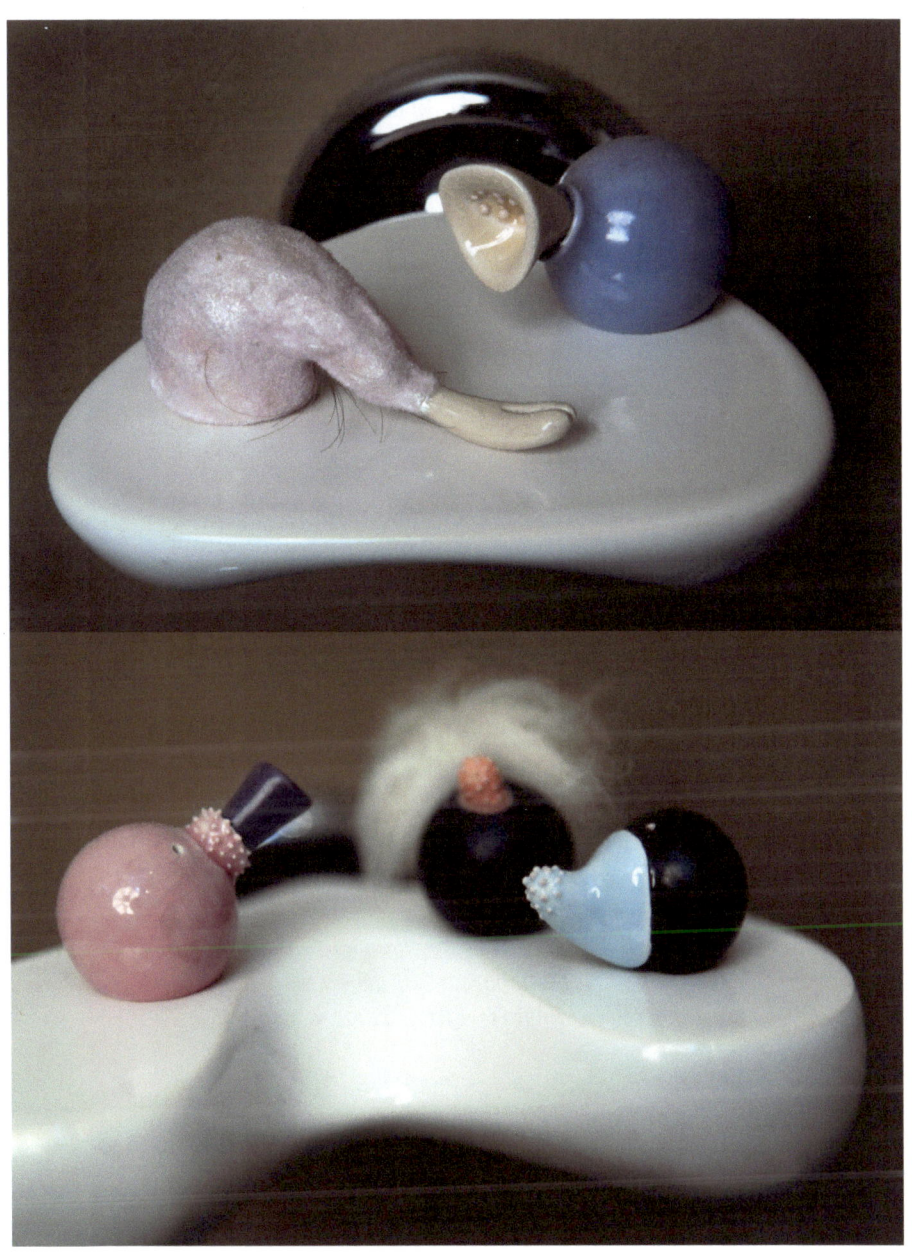

Andy Oleksiuk

Impetus "I believe that art can uplift the spirit. Using good design and aesthetics, a mere painting can inspire wonder and instill a sense of satisfaction or fulfillment in the viewer. While many types of art can have this or any other goal, I believe this is the highest functional goal art can achieve. So in this there is a sense of purpose and doing 'good' for humanity. Of course every artist might try this in their own warped way and there is no correct solution. I recall as a very young artist sharing my drawings and paintings and receiving positive feedback. While I am sure it was gratifying for me, I was even more inspired that my communication affected someone positively. In return I received the feedback but the joy was in having an impact on someone's psyche – achieving a teaching moment however brief and stimulating the imagination of others."

R&D "My painting references the whimsical nature of humor, and also language and semiotics. It is also inspired by simplicity of design. There is inherent in my work a delicate interplay between abstraction and meaning. On the one hand, the landscapes can be seen a purely abstract and simple minimal illustrations of place. However, there exists a vocabulary of constructed meanings made up of symbols, forms and process. Like language, a finite set of elements used in complex variety can create an infinite number of meanings. And so my paintings are commentary on both the utility of language and narrative, and the importance of meaning and purpose in life."

Mainstream application "The trajectory for this work suggests a design consultancy that provides a wide range of business solutions for customers. By inspiring clear communication and a positive outcome, the business model enables a feedback loop of doing "good" by creating wealth and creating wealth by doing good. The aim of the firm is to help connect the dots for business partners and customers, and to strive for simplicity in management by design."

Author's Extension of the Mainstream application.
I think that Andy could establish a design and marketing firm for social entrepreneurs. The artist will be able to play with his interest in "a delicate interplay between abstraction and meaning" in the same way that social entrepreneurs play with seemingly conflicting principles of profit and social change. This artist and social entrepreneurs are both interested in the thought those things that are generally accepted as opposites are not necessarily mutually exclusive. The marketing and design projects produced for these businesses would be works of art that address duality of perception and purpose. In this way this firm will utilize the underlying conceptual base of "doing good", its interest in clear communication and a positive outcome to help social entrepreneurs have a positive impact on society. It would be more than a design firm; it would be a joint partner with these special entrepreneurs in effecting social change.

Megan Abajian

Impetus *"I have the mind of a boy. I enjoy most things taboo. I think it's funny. When I was younger I would break open roly-polies to see what was inside—not all roly-polies, only the ones that had white stomachs. I thought there were babies in there. It is this same attitude of discovery that I experience in my studio. I enjoy exploring the grotesque, all the slimy, squirmy forms that really should not be seen, we pretend they are not there. Skin is wonderful casing for all things gooey. I like what is under the skin. It makes me giggle and cringe at the same time. I want the viewer to do the same when they experience my work. The goal is for my paintings to have the same innocent cruelty as that of a child who pulls the legs off a spider.*

My dream painting would look like it's either a section of your gut, a parasite attached to a vital organ, or something you expelled from your body—if it could have hair, even better."

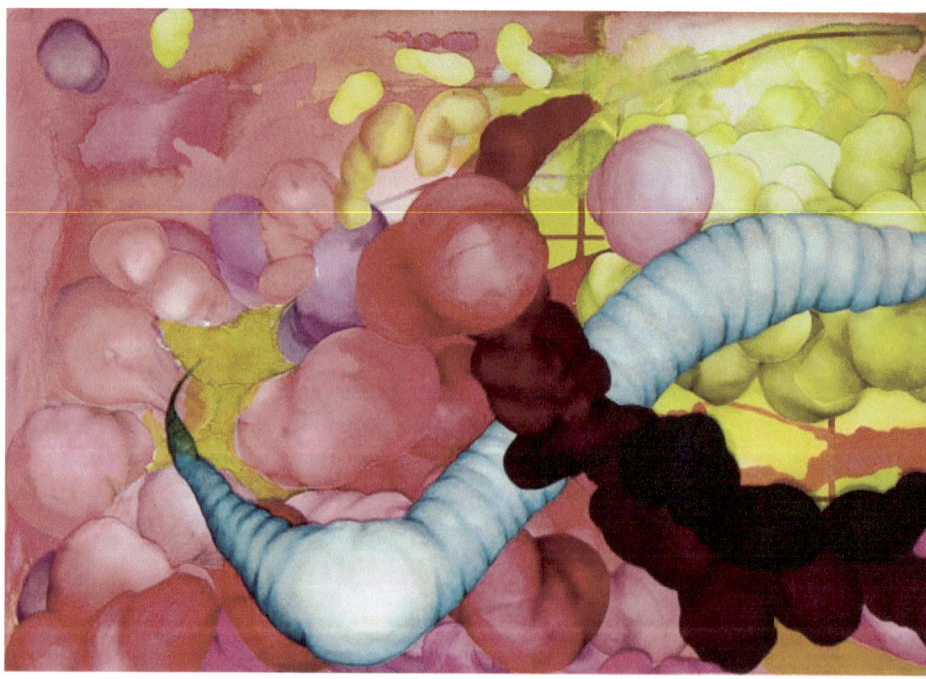

R&D Collaged paintings and fiber wool sculpture which simultaneously delight, invite and create the realization the messiness of life within the viewer.

Mainstream application Produce toys (sex and otherwise) and candy which allow us to discover the playground of our bodies and the world around us. Toys and candy would allow the artist to enjoy exploring the possibilities of discovering all the beautiful sweetness of the slimy, squirmy and grotesque. This contribution helps children to delight in what they naturally gravitate towards and reminds adults to not forget this valuable part of their humanity. One possibility would be to partner with a company that makes coin operated game/gumball machines. The innovation would sell more machines and the endeavor would expose the artwork to a broader audience.

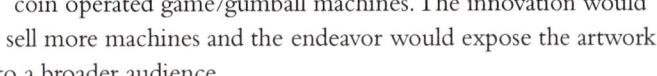

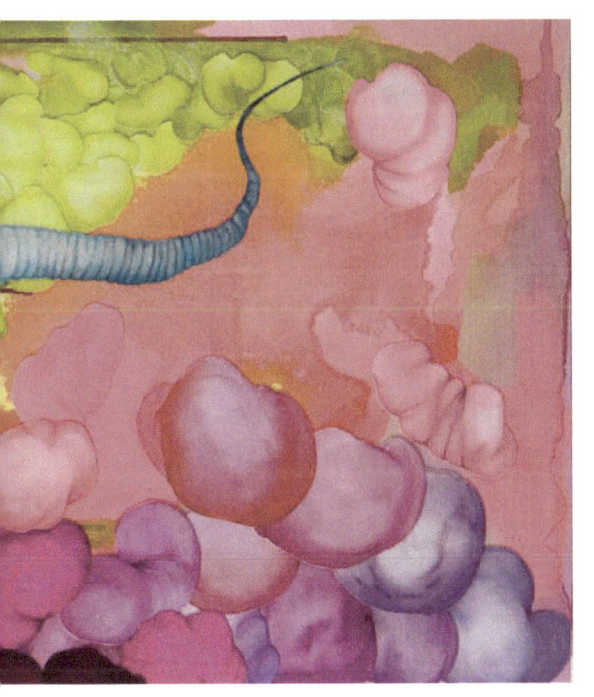

Susan Smith Trees

Impetus *"My intention is to explore the ways in which humans protect themselves from both alienation and exposure. I wrap my figures in cocoon-like cloaks and use the shroud as a protective shield that creates a place of safety and a retreat for healing. The forms I sculpt are meant to embody a range of psychological states from fear of scrutiny to the strength of vulnerability. This strength is gathered from entering into a kind of monastic refuge where the heart abides unto itself in order to emerge from the cocoon self-sustained."*

R&D Susan is producing bronze figurative-like sculptures which seem to have a life within them. The bronze is almost breathing and the viewer wonders if they will begin to move as they are experiencing them.

Mainstream application If Susan were to apply her work to create a business she would be interested in utilizing the work in intimate spaces used for retreat. She would duplicate and enlarge her sculptures so that they could be used as ballast for foot bridges, supports and/or arms for park benches. Another project that would interest her would be a fountain for a healing garden. A retreat or garden with this work included as an integral part of the experience would allow her to explore psychological states in a place of refuge. This garden would also give people a place to retreat to face their own vulnerability and find the strength within their own vulnerability. This personal journey parallels the experience of viewing the sculpture and the journey the sculpture initiates would then be complete.

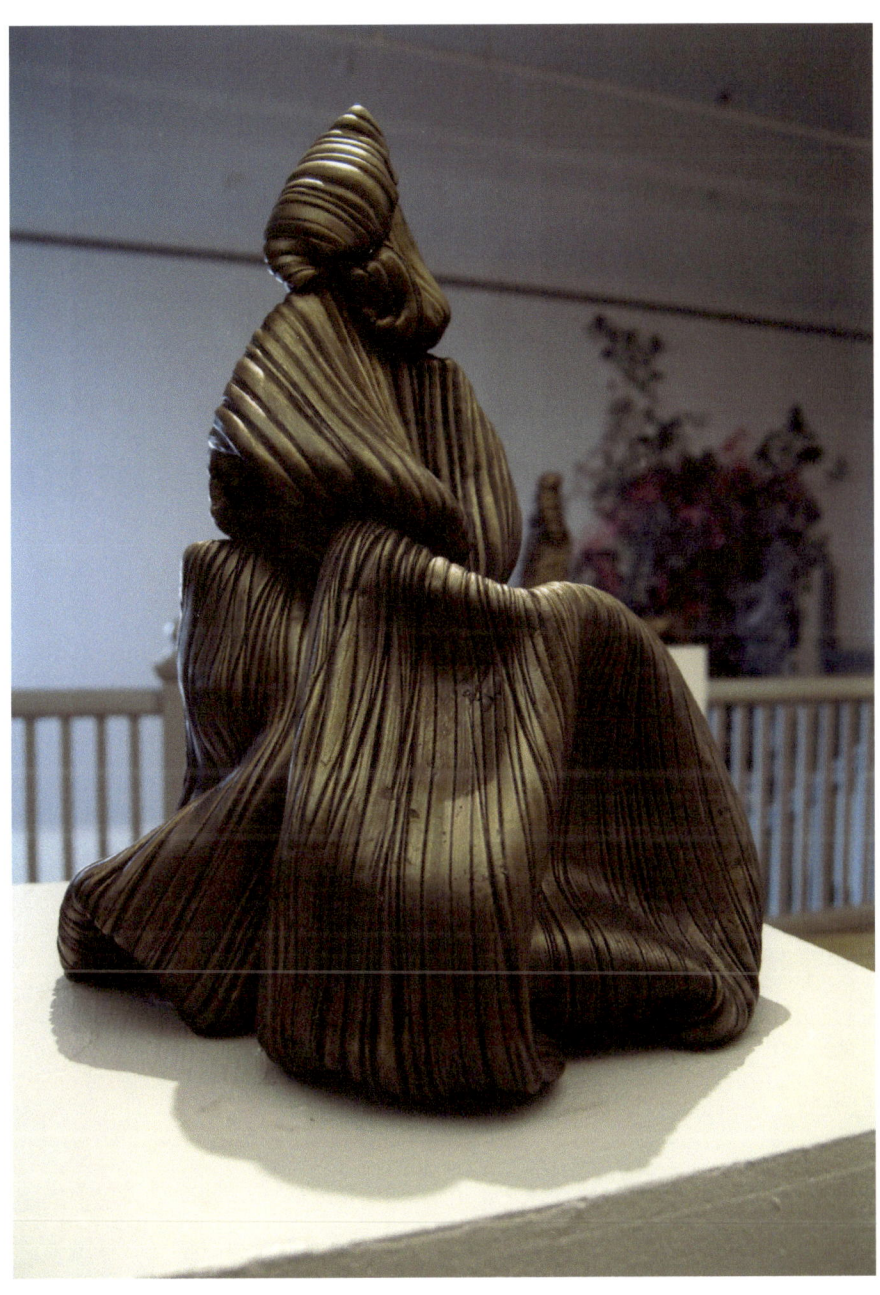

The journey of a thousand artists

begins with a single business.

Calculated Leap was fully realized by Theresa Devine in Chicago, IL. Its creation began in 1999 when "The Gift of Fire" was written in Houston, TX. Complete understanding that these essays would become a book was solidified in 2004 when "When Impulsiveness Becomes a Calculated Leap" was written. Theresa Devine received her BFA from TAMUCC in 1991 and her MFA in 1994 from UH. She currently teaches in the Interactive Art and Media Department at Columbia College Chicago and is the Chief Executive Artist of Toxic Interactive, LLC.

The artists that were included in the book all own the copyrights to their own work and artist statements and in agreeing to participation in the book have given legal permission to use their work in this context. Any articles in this book may not be used for any and all broadcasting, advertising, digital distribution, or exploitation of any type, whether audio or visual, or for any purpose in any manner or media, whether now known or hereafter devised, in perpetuity throughout the universe without the expressed permission of Theresa Devine, who is the sole owner of this copyright.

www.theresadevine.com
www.calculatedleap.com

www.ingramcontent.com/pod-product-compliance
Lightning Source LLC
Chambersburg PA
CBHW041110180526
45172CB00001B/186